PLAT OF UNION. This early map shows the original plat of the town plus additions that were made prior to 1878. Note the Union Mill in the upper right, which was the scene of a Civil War skirmish during Price's Raid. The mill is still standing and is in use as Crystal Ice and Fuel.

ON THE COVER: UNION CORNET BAND. The Union Cornet Band was the earliest known organized band in the community. Band members were enjoying an outing on the Bourbeuse River, which was a popular place for locals to fish, swim, and picnic. The date of the photograph is not known. (Courtesy of Washington Historical Museum.)

IMAGES *of America*

UNION

Sue Blesi

Copyright © 2013 by Sue Blesi
ISBN 978-1-4671-1104-1

Published by Arcadia Publishing
Charleston, South Carolina

Printed in the United States of America

Library of Congress Control Number: 2013939204

For all general information, please contact Arcadia Publishing:
Telephone 843-853-2070
Fax 843-853-0044
E-mail sales@arcadiapublishing.com
For customer service and orders:
Toll-Free 1-888-313-2665

Visit us on the Internet at www.arcadiapublishing.com

This book is dedicated to all of those who research Franklin County history and who have cared enough to share their findings.

CONTENTS

Acknowledgments		6
Introduction		7
1.	Leadership and Services	11
2.	The Streets of the Town	21
3.	Where They Worked	29
4.	Where They Learned and Worshipped	73
5.	Diversions in Union	97
6.	Roads They Traveled	107
7.	Who They Were	115
Bibliography		127

ACKNOWLEDGMENTS

Although it would be impossible to acknowledge every individual who has provided help in the course of producing this book, I want to begin by thanking the Washington Historical Museum, Four Rivers Genealogical Society, Scenic Regional Library, Union City Hall, Franklin County Historical Society, and the Union Historical Society, which, although disbanded, was still willing to share photographs with me. Tamie Brueggemann spent many hours getting photographs from a 12-year-old Macintosh computer into a format that could be opened on my computer. Marc Houseman, director of the Washington Historical Museum, has provided assistance in many ways. Carol Radford, chairman of the St. Clair Historical Museum, Marc Houseman, and my husband, Glen Blesi, have proofread and, to the extent practicable, checked facts. A special debt of gratitude is due each and every person who provided photographs or information.

INTRODUCTION

The Franklin County, Missouri, town of Union had an interesting beginning. The site was carefully chosen, and the town was carved out of the wilderness. The location was not picked because it was on a major river. Nor was it on the expected course of the coming railroad. Instead, the location was chosen because it was near the center of the newly-defined county.

The Territory of Louisiana was established on March 3, 1805. The Territory of Missouri, organized on June 4, 1812, was originally divided into five districts, later called counties. They were Cape Girardeau, New Madrid, Ste. Genevieve, St. Charles, and St. Louis. In 1818, Franklin County was cut off from St. Louis County, but it extended to the Osage River on the west, Washington County on the south, the Missouri River on the north, and the present boundary on the east. On August 10, 1821, Missouri was admitted into the Union as the 24th state.

Most of the earliest pioneers had settled along the river, so the county seat was established at Newport, and a courthouse was built. Rogerstown, an Indian village, was the only settlement within present-day Franklin County prior to Newport. The county was reduced to its present boundaries in 1820. Gasconade County and portions of both Osage and Maries Counties were formed from the territory that had been removed from Franklin County. The southern part of the county was becoming increasingly populated, which meant that Newport was no longer a good site for the county seat. John Stanton, who lived on the Meramec River in the area that later became the town of Stanton, was elected as a county judge, a position analogous to the present-day county commissioner, and he had to make the long journey on horseback.

The taxpayers petitioned to have the county seat moved to a centralized location. In 1825, the state legislature appointed John Brown of St. Louis County, Benjamin Horine of Washington County, and William Lamme of Montgomery County to select a place within three miles of the center of the county to be the new county seat. Because none of these men were from Franklin County, they had no vested interest in the decision.

Brackett Barnes, Barnabas Strickland, and Moses Whitmire were appointed to arrange for the land to be purchased or accepted as a gift. Three farmers, all living in log houses in the midst of mostly uncleared acreage, gave land for the new county seat. Reuben Harrison gave 30 acres, Nathan Richardson gave 37.5 acres, and Phineas Adams gave 5 acres. Altogether, the new town consisted of 72.5 acres. Union was essentially carved out of the wilderness.

Documentation regarding the choice of "Union" as the town's name has not been found. It was named 30 years prior to the Civil War, so it is not related to the Union-Confederacy conflict. Also, it had nothing to do with labor unions. Two possible explanations are that it related to the union of states, reflecting local patriotism, or to the uniting of the people from the far corners of the county in the form of a centralized county seat.

The town was laid out into 42 blocks and seven partial blocks. The plat was filed on February 6, 1832. The square, which as yet contained no courthouse, was framed by Church, Oak, Locust, and Cedar (later Main) Streets. None of the streets were named for the three men who had so

generously given their land on which the town was built. People who had owned lots at Newport were able to exchange them for lots in Union.

The date of construction of the brick church that once stood in the middle of Church Street is of particular interest. Lucy Lomax, in her book *History of Union: 1827–1976*, mentions that a letter written by A.J. Coleman stated it was probably built about 1837. This raises the question of the origins of Church Street, named so in the 1832 plat.

Because the new town was to be the county seat, the first order of business was to find a place to hold court and transact the county's business until a courthouse could be built. Ambrose Ransom, who had owned land at Newport, was quick to erect a large two-story, double-log house. The county court met for the last time at Newport on November 7, 1826, and for the first time in Union on June 25, 1827. It rented space in Ransom's home until a courthouse could be built.

James McDonald had the contract to build the courthouse. When he was not paid per his expectations, he refused to complete the job. William G. Owens and Ambrose Ransom were asked to supervise the completion of the structure, which still needed doors, windows, panel work, and some flooring. The county's quarrel with McDonald came to a head when McDonald filed suit against the county court for payment. A judgment in the amount of $3,432.25 plus costs was made against the county, and Sheriff C.S. Jeffries seized the courthouse and jail at Union and the old courthouse at Newport and advertised them for sale. The courthouse was to be sold on the courthouse steps! The sale took place in May 1832, and McDonald had the high bid at $210. The county court at the time consisted of Matthew Caldwell, William R. Ellett, and John Gall. This incredible mess was not resolved until two years after McDonald's death, in 1837, when his heirs settled the matter with the county.

Preston G. Rule, also a Newport transplant, had the first general store in Union. He was appointed to be the first postmaster of Union on July 20, 1827, and likely maintained the post office inside his general store. Although other post offices had been established earlier in the county, they have ceased to exist and Union is now the oldest post office in the county. Rule married Judith Stanton, the daughter of the early county judge John Stanton.

Wilson E. McEuen, a blacksmith, settled in Union about 1827. After earning enough money to buy a farm, he moved to the Anaconda community. Married twice, McEuen fathered a total of 25 children, including six sons who were killed in the Civil War. Phineas Thomas is the next blacksmith of record. Blacksmiths were essential in all pioneer communities, as they made and repaired farm equipment, tools, and wagons, and shoed the horses that were the mainstay of transportation.

Alexander Chambers was another early settler. He kept a tavern in a log house and later built the large hotel that stood on the northeast corner of the courthouse square. The hotel building was replaced by the old post office, which still stands at that location.

William Walker had a general store by 1830 and owned a four-story flour mill on the Bourbeuse River below the bridge. Buckner and Robinson also had a general store in 1832. Dr. Elijah McLean is the earliest doctor of record. He had a log house on the northwest corner of Block 67. Dr. McLean married Judith (Stanton) Rule in 1831, after the death of her first husband, Preston Rule. The McLeans later moved to Washington.

Although the early records for the Village of Union have not been preserved, it was reported that the village was incorporated on August 18, 1848. The first town board of trustees consisted of Alexander Chambers, John G. Chiles, David Edwards, Farmer Harper, and John T. Vitt, with attorney James Halligan serving as clerk. There is some confusion about the matter, as Clark Brown wrote in 1915 that the town of Union had been incorporated on February 15, 1851. He named Farmer Harper, Elisha B. Jeffress, Samuel L. Kennett, David Robertson, and John T. Vitt as the trustees at that time. The town was incorporated as a fourth-class city on August 11, 1888. Jeffress was killed in the 1855 Gasconade River disaster, in which a train making its maiden voyage across the bridge plunged into the river when the bridge failed to support its weight.

In 1874, a serious attempt was made to have the county seat moved from Union to Washington. Following a public meeting at Turner Hall, Washington citizens passed a resolution that $20,000

be appropriated for that purpose. There was a vote on November 3, 1874, but the required two-thirds majority was not achieved.

The Civil War came to Union in the form of Price's Raid, on October 1, 1864. Two men, probably Jack Maupin and Jake Stewart, rode into Union and reported that the Confederates were in or near St. Clair. The companies of Henry Detmer and Henry Gillhouse began erecting breastworks in the woods below Vitt's Mill, hoping to gain control of the Union end of the Bourbeuse River bridge. J.H. Hanneken described their efforts thusly: "The breastworks were made of rails with earth put between the rails. We all worked like beavers. Those who had shovels piled the dirt and those who had none carried rails. Late that afternoon, the Confederates approached the bridge and Detmer and Gillhouse had their men ready. Captain Detmer, in a loud, firm voice, shouted, 'Ready, Fire!' Then he said, 'Load! Ready, fire!' He repeated the last command a second time. Then they heard the cannon on Gorg's Hill south of town and imagined they heard cannon balls in the trees above their heads. Captain Detmer shouted, 'Everyone for himself!' That was the last order given at the Battle of Vitt's Mill."

With as many as 10,000 troops in the county, there was widespread destruction. Bridges were burned and railroads destroyed. Homes were invaded. Food and horses were appropriated for use by Confederate troops. The predecessor of the Red Bridge was destroyed, not by fire, but by the troops who marched across the bridge with cannons and other equipment in addition to their pilfered loot. A few men were killed, but the size limitation of this book prevents a detailed account.

Very little information is available about the role of black people in early Union. In the 1851 Articles of Incorporation, it was specified that the town board had the right to prevent or restrain the meeting of slaves. After emancipation, black children were educated separately until 1954, when segregation ended. Their school was called the L'Overture school, named in honor of Toussaint Louverture, a Haitian revolutionary hero who had been born into slavery in the 1700s. Among the black leaders of Union, George A. Maston stands out. Born into slavery in 1849, he obtained a college education and made his way to Union in 1883. An ordained minister of the African Methodist Episcopal faith, he pastored the black church in Union and taught at the black school for six years. In addition, he worked as a barber at the Union Hotel, where he was only permitted to have white clientele. Although his tenure in Union was short, he made a big impression and inspired his students and church members to achieve more. In 1883, Maston witnessed the murder and mutilation of a black man by a white man, whose crime was reduced to manslaughter, resulting in only a three-month sentence in the county jail and a $400 fine. Union's black history is presented in more detail in Linda E. Mahon's 2000 master's thesis (see Bibliography, page 127).

There were numerous early private schools, usually known as "select" schools, supported by parents who paid tuition. After public education was established, select schools often provided additional education to those who could afford it, as school terms were short. "Academies" were established as well, but the quality of the education they provided did not deserve the name. It is known that Rev. Fenton taught a private high school in the old Presbyterian church in 1875. Exactly when and where Union's first public school was established is not known. However, in 1870, Union had a six-month school term with two teachers. The white school had an enrollment of 81 males and 98 females. The black school had an enrollment of 22 males and 36 females.

Lomax reports in her *History of Union: 1827–1976* that the first public school building was a log structure where Zion United Church of Christ is now located. A black church was once located next to the Zion church and likely housed the black school as well. The next public school was a two-story brick building that was converted to a residence in 1888. A brick grammar school completed in 1887 was located on the site of Central Elementary. That structure was razed and a new school built in 1938, which has also been replaced. A new high school was ready for occupation in 1917. A two-year high school was established in 1903. In 1906, it became a four-year high school.

The coming of rail service in 1887 was a milestone in the history of Union. It was the culmination of years of negotiations with the St. Louis, Kansas City & Colorado Railroad. Rail service had

reached Washington to the north before 1855 and St. Clair to the south in 1859. The railroad was of great importance, not only providing people with greater mobility, but bringing in goods theretofore unavailable in the community and providing a means for locals to ship their products to the St. Louis market. Another benefit of the railroad was the development of an early tourist industry. City folks wanted to escape the heat in the era before electric fans and air-conditioning. They sought out the cooling waters of the Meramec and Bourbeuse Rivers for fishing and swimming, often coming out by train on a Friday and returning to the city on Sunday evening. There are numerous accounts of city people coming to Union on the train to attend fairs and other events.

Much infrastructure development took place in the last two decades of the 1800s and the first decades of the 1900s. A telephone line connected Union to Washington in 1883, but widespread telephone service was slow in coming. In 1894 electricity came to Union, supplied by Anton Tibbe's plant in Washington. Electrical service did not reach all of the rural communities until the 1950s. The first public waterworks in Union was established in 1897, pumping water from the Bourbeuse River. In 1911, early city sewers were in service, dumping sewerage into the river!

With the invention of the automobile, Union, and the county as a whole, found itself with cars, but no place to drive them. The roads were impassable much of the year due to mud, snow, and the deep ruts made by wagon wheels. There were few bridges, and those that existed had not been built for automobiles. Therefore, the focus turned to building better roads.

From this beginning, Union developed the basis on which to grow and prosper. With electricity available, several industries sprang up, bringing on a growth spurt such as the town had not seen since the arrival of the railroad. Today, Union is a thriving city with a good mixture of industry and commerce. Because of its role as the county seat, there are numerous attorneys and county officials living in Union or maintaining their offices here. Because of its proximity to St. Louis, many residents commute to jobs in the city. Others, with local employment, take advantage of entertainment and shopping in St. Louis.

One

LEADERSHIP AND SERVICES

UNION'S FIRST "COURTHOUSE." Although not actually a courthouse, this log building was the first place in Union where the circuit and county court convened. Ambrose Ransom's tavern and hotel later served as John Zielinski's home and business. Zielinski had a saloon and was also a saddler from 1874 to 1920. This photograph was taken after the siding was removed in preparation for demolition. (Courtesy of the author.)

COURTHOUSE BUILT IN 1849. This courthouse served Franklin County citizens from 1849 until it was demolished to make room for the historic courthouse, which was completed in 1923. The cost of the 1849 structure was $5,000. It was the scene of several well-known trials, including those of William Rudolph and George Collins. An earlier courthouse was completed in 1828, but no photographs of that structure have been found. (Courtesy of Ralph Gregory.)

SELLING COURTHOUSE MATERIAL. Following the demolition of the 1849 courthouse, an auction was held to dispose of reusable material. Herman F. Hansen was in charge of selling all lumber, roofing, windows, columns, doors, desks, and shelves from the old courthouse. In the background, the old county jail with the fire bell tower can be seen. At far right is J.E. Wieneke's store. (Courtesy of Gary Voelker.)

BUILDING THE COURTHOUSE, 1922. It is amazing to think of the changes in building technology that have taken place since the present "historic" courthouse was completed in 1923. In the above photograph, draft animals are utilized to prepare the construction site. The Union Lodge No. 593 AF & AM laid the cornerstone for the new courthouse on Labor Day 1922. In an era when hi-tech entertainment was unheard of, area residents often watched the progress of construction. Photographing the site was a favorite pastime of area shutterbugs. The cost of the new building, including heating system, furniture, and fixtures, was a little over $200,000. (Both, courtesy of Gary Voelker.)

Courthouse Flanked by Scaffolding. The 1923 courthouse was 90 feet square, built of reinforced concrete with walls of Bedford stone and a Carthage stone base. Each of the three floors contained 8,100 square feet of space. In the early years, a county jail and gallows (unused) were located on the third floor. (Courtesy of Bernice Holtgrewe.)

American Legion at Courthouse Dedication. Union American Legion Post No. 297 was on hand for the 1923 dedication of the courthouse. Shown here are, from left to right, (first row) Hiney Mahoney, John Rees, Jess Overschmidt, George Hug, Frank Fink, Landon Eads, Sigfreid Jacobsmeyer, Ludy Mintrup, and Franz Beinke; (second row) Mack Crider, Monte Murray, Albert Keller, Leonard Doerr, Edwin Tappe, Gordian Busch, John Rapp, Edwin Fees, Dr. Raymond Lichte, and August Steinbeck. (Courtesy of Washington Historical Museum.)

FRANKLIN COUNTY POOR FARM. Also known as the county infirmary, this building was constructed to house the indigent in 1916 at a cost of $19,586. William Dress served as superintendent for 30 years. Today, the original structure is part of Sunset Nursing Home. An earlier structure on County Farm Road had no running water or electricity. Inmates who were able were expected to help with chores. (Courtesy of Bernice Holtgrewe.)

UNION CITY HALL AND FIREHOUSE. This structure, built in 1948, housed the Union Police Department and city jail in the basement, the Union Fire Department and a meeting room on the third floor, and from 1948 until 1972, city hall on the main level. (Courtesy of the author.)

UNION POST OFFICE. Once located on the northeast corner of Church and Main Streets, later the site of Todd Buick-Pontiac, this building served as the post office from 1904 to 1938. The men shown here are, from left to right, Adolf Borberg, Dr. J. Volney Denny, Emil Szymanski, and Clark Brown. (Courtesy of Ralph Gregory.)

POST OFFICE EMPLOYEES, 1930s. Shown here are, from left to right, (kneeling) Arbie Campbell and Casper Bassman; (standing) Charles Tessmer, Henry A. Klepper, Rosalie Eschbach, postmaster Hattie Stierberger, Sophie Peters, Franz Bienke, and Emil Hermann. (Courtesy of Union City Hall.)

THE OLD POST OFFICE. Built in 1938, the old post office served the public until 1995. The old Union Hotel was razed to make space for the new post office. The hotel was purchased from Edward Danz, and a strip of land to the rear was purchased from Mrs. Anton Kramolowsky. Today, the building is known as Old Post Office Antiques. (Courtesy of Ralph Gregory.)

UNION SLAVE HOUSE. This somber reminder of slavery once stood between the present-day County Government Center and city hall. Considering its close proximity to the courthouse, it might have been used to house runaway slaves or to hold slaves waiting to be auctioned. It seems unlikely that it would have housed slaves belonging to a private party because the structure had one door and no windows. It was dismantled in 1972. (Courtesy of Franklin County Historical Society.)

OLD COUNTY JAIL. The stone jail was built in 1856 by A.W. Jeffries for $6,700. Stone to build the structure was quarried on a farm about a mile west of Union. The farm property was owned by J.A. Fees in 1915. In 1906, a tower for the fire bell was built next to the jail, which was located on the southeast corner of Church and Locust Streets. (Courtesy of Washington Historical Museum.)

UNION FIRE DEPARTMENT, 1949. The Union Fire Department organized in 1890 following a courthouse fire. The members met in Judge A.H. Bolte's office. J.G. Moutier was elected captain; Robert Mueller, first assistant; Joseph Eckert, second assistant; A.F. Mauthe, secretary; Emil Szymanski, pump master; and Louis Max, assistant pump master. (Courtesy of Washington Historical Museum.)

UNION MEMORIAL AUDITORIUM. Built as a memorial to World War I casualties, the Union Memorial Auditorium was originally intended to house city government, but city offices did not occupy the building until 1972. Completed in 1938, it housed the public library until April 1961. From 1969 to 1972, the auditorium was leased to the newly organized East Central College for classroom space. (Courtesy of Ralph Gregory.)

UNION FIRE DEPARTMENT. The Union Fire Department poses in front of the historic courthouse in 1944. The men are wearing fire gear consisting of raincoats, boots, and World War I helmets. (Courtesy of Pautler collection.)

FRANKLIN COUNTY JUDICIAL CENTER. The Franklin County Judicial Center is a three-story, 40,000-square-foot building that houses two circuit courtrooms and three associate circuit courtrooms. The building also has space for judges' chambers and for support operations, such as court reporters, administrators, and the court clerk. Replacing the 77-year-old Strubberg Hardware building, it was built to mirror the new government center, creating a unified complex. (Photograph by the author.)

FRANKLIN COUNTY GOVERNMENT CENTER. Completed in 2006, the Franklin County Government Center is a two-and-a-half-story, 45,000-square-foot facility that provides space for county offices, including commissioners, clerk, assessor, collector, recorder of deeds, planning and zoning, and building department. The cost of the government center was $7 million. (Photograph by the author.)

Two

THE STREETS OF THE TOWN

EARLY VIEW FROM NORTH OAK. Highway 50 had not been built when this photograph of North Oak Street was taken. Note that the street was a dirt road. The courthouse in the distance was replaced in 1923. (Courtesy of Barbara Jeffs.)

NORTH SIDE OF COURTHOUSE SQUARE. Kramolowsky's Saloon (left) stood on the corner. Anton Kramolowsky also operated a wholesale liquor operation. In later years, his son-in-law, Felix Pautler, operated the Pautler Store at that location. The second building on the left is the Mueller Shoe Store. At the end of the block, the Union Hotel can be seen. (Courtesy of Pautler collection.)

VIEW FROM COURTHOUSE TOWER. This view of Union shows the area north of the courthouse square. In the foreground is the Union Hotel, which once stood where Old Post Office Antiques is today. This photograph was taken from the tower of the old courthouse, creating a resemblance to an aerial view. (Courtesy of Pastor Adolph Henry Bisping collection.)

CEDAR STREET VIEW. Main Street was known as Cedar Street at the time this photograph was taken. The buildings here are, from left to right, Kramolowsky's Saloon, the Mueller Shoe Store, and the Union Hotel. (Courtesy of the author.)

SECOND VIEW FROM COURTHOUSE TOWER. This view of the area north of the courthouse square was taken later than the photograph on the previous page. The Anton Kramolowsky home can be seen behind the Union Hotel. It had not been built when the earlier photograph was taken. (Courtesy of Gary Voelker.)

HEIN HOME AND BUSINESSES. The J.W. Hein Tailor Shop once stood on the northwest corner of the courthouse square, catty-cornered from the courthouse. The building to the left is a millinery shop. On the far left is the Hein home. (Courtesy of the Paul Hein collection.)

SOUTH SIDE OF COURTHOUSE SQUARE. This view, also taken from the courthouse tower, shows businesses that stood on the south side of the square. The corner building is the Bank of Union, which was robbed by William Rudolph and George Collins in 1903. The *Republican Tribune* newspaper office and printing plant is on the right. (Courtesy of Gary Voelker.)

MAIN STREET, LOOKING EAST. This view of Main Street shows an early Ford dealership on the right. Note the old-style gas pump in front. Customers must have pulled in parallel to the curb to fill their tanks. (Courtesy of Dorothy Maune Sudholt Williamson collection.)

MAIN STREET, LOOKING WEST. This photograph, taken from the corner of Main and Church Streets, appears to have been taken during the final stages of construction on the courthouse. The old drugstore (center) and other Oak Street businesses can be seen. (Courtesy of Dorothy Maune Sudholt Williamson collection.)

SOUTH OAK VIEW. One of the children of Felix and Elsie (Kramolowsky) Pautler stands in the foreground of this view of Union from South Oak Street. This photograph was taken before Highway 50 was built and before the street was paved. The Pautler home stood where Margo's Flowers and Gifts is now located. The home was purchased by Denny and Margo Eckelkamp and moved to St. Jordan's Church Road in the Jeffriesburg area in 1995 or 1996 to make room for their business. (Courtesy of Pautler collection.)

OAK STREET, 1930s. This photograph shows two drugstores on the east side of the courthouse square, both of which served ice cream. The business in the center of the block is Noll Drugs. The two-story building at the far end of the block is C.J. Arand's store. D.W. Breid's law office is above the corner drugstore. Note the angled parking on both sides of the street. (Courtesy of Gary Voelker.)

EAST MAIN, OFF OF THE SQUARE. Establishments shown here are, from right to left, Schultz Clothing, Union Electric, Birk's Variety, Purschke's Garage, and the Federated store. Theodore "Ted" and Leander Bocklage bought Schultz Clothing in the early 1940s, when Mr. Schultz was recalled to active duty. Ted took charge of the Union store, obtaining a military deferment. Despite having a wife and three children, Ted was eventually drafted, but the war ended before he was inducted. (Courtesy of Gary Voelker.)

OAK AND LOCUST STREETS. These photographs were taken after the 1849 courthouse was demolished and before the present building was constructed. Above, Elmer's Tavern, which had a different owner, is partially visible at far left, followed by Freddie Graham's barbershop, Noelke's Coffins, Busch Furniture and Hardware, and the old county jail. Below is a Locust Street photograph, also without a courthouse to obstruct the view. The two-story brick building near the left side is the Bank of Union, followed by the *Republican Tribune* office and printing plant, Union Bakery, and a large business building with three entrances that had different occupants over the years. On the far right, a sign proclaims "Day & Night," and "Union Shoe Store, Harness and Shoe Repair." (Both courtesy of Gary Voelker.)

Three

WHERE THEY WORKED

HISTORIC HANSEN BUILDING. This structure at 15 North Oak Street was the 1891 home and business of Union watchmaker and mayor John Mueller. Shown on the balcony are Mueller (left) and Harry Reinhard. Owned—and previously occupied by—Bob Hansen, it is now home to the Franklin County Historical Society. The Emma Hein home to the right was later the office and residence of Dr. W.G. Tainter. The man below has not been identified. (Courtesy of Steve Claggett.)

THE UNION HOTEL. Located on the northeast corner of the courthouse square, this hotel was built in the summer of 1846 by Alexander Chambers. Fritz Koirtyohann hauled the bricks from Washington. It was a going concern until 1937, when it was demolished to make way for the post office. Over the years, it has also been known as the Moutier Hotel and the Hobelmann Hotel, among other names. (Courtesy of Gary Voelker.)

RESSEL BARBERSHOP AND LEFHOLZ BEAUTY SHOP. The Ressel Barbershop and Lefholz Beauty Shop were operated by Walter Ressel and Adelle Lefholz. They were first located in the old Federated store on East Main Street and later across the alley from the White Rose Café. (Courtesy of Union Historical Society.)

PURSCHKE TIRE AND OIL. Bob Purschke poses beside the Red Sentry gas pump at his father's garage. In 1915, Ray Purschke realized that Union needed a garage to handle repairs, as area residents were starting to buy cars. The *Franklin County Tribune* reported that 100 automobiles had been in Union on Labor Day 1915. Ray tore down his blacksmith shop on North Mulberry and built a garage. He built a new service station and garage two years later on East Main Street, where Bugsy's restaurant is. George Gildehaus moved his soda bottling plant into Purschke's old building. Ray's grandsons, Robert "Pete" and Richard Purschke, operate Purschke Tire and Oil at the Highway 50 location their father bought from Leo Peirick in 1954. Pete's sons, Seth and Brent, and Richard's son-in-law, Jason Machelette, are now part of the business. (Courtesy of Pete Purschke.)

SERVICE STATION ON EAST MAIN. Joe Klenke stands in front of a filling station that was once located where the White Rose Café is today. This photograph was probably taken between 1910 and 1922. A Shell service station, it specialized in repairing tires and innertubes. Note Reymer's Drugstore at the far left. (Courtesy of Duane Campbell.)

WHITE ROSE CAFÉ. The White Rose Café, started by the Schroeder family, has been a popular eatery in Union since about 1925. It specializes in good home cooking and a variety of home-baked pies. An earlier building featured a tree growing in the center. In 2013, the establishment celebrated 88 years in business. (Courtesy of the author.)

MASSEK-MURRAY MOTOR COMPANY. The Massek-Murray Motor Company was a Ford dealership located on East Main Street, behind Elmer's Tavern. The business was owned by Omar Massek and Walter and Cy Murray. It was relocated to Highway 50 and that second building later became home to Bob Barreth's Ford, then Charlie Counts Ford. It was demolished when MotoMart was built. (Courtesy of Washington Historical Museum.)

OAKLAND DAIRY FARM. Orlando Helling operated the Helling Dairy Farm in the Indian Prairie community southeast of Union. He operated milk routes in both Union and St. Clair. The dairy was sold to Missouri Valley Creamery in December 1940. The farm is still in the Helling family. (Courtesy of Rose Helling.)

Hilkemeyer Shoe Store. L.G. Hilkemeyer and a partner, B.F. Brunnert, bought J.G. Moutier's general store in 1905. A year later, Hilkemeyer bought out his partner and continued the business on his own, billing it as "Union's Leading Store." In 1922, he opened the Hilkemeyer-Stevens Clothing Store. (Courtesy of Dorothy Maune Sudholt Williamson collection.)

Neimaier-Reinhard Store Interior. Neimaier and Reinhard had a mercantile business in Union from about 1853 until Neimaier's death in 1863, after which Charles Reinhard Sr. continued the business alone. Later, his sons, William F. and Charles P., took over the store. (Courtesy of Paula Hein collection.)

WILLIAM HORN FUNERAL HOME. William Horn managed Union Furniture Company, which was owned by the Otto family. The business also sold caskets. The Otto family purchased this building, located east of Frick's Market. William Horn operated it until 1956, then Kenneth Wehmueller managed it for several years. Stanley Meyer bought the funeral home from the Otto family in 1969 and operated it for approximately 10 years. (Courtesy of Gary Voelker.)

WILLIAMS THEATRE. William Horsefield and C. A. Rieger first owned this theatre. It was purchased by Dr. and Mrs. David E. Williams in 1934 and later owned by L. J. and Letha (Jenny) Williams. Located at 101 West Main Street, it burned and was rebuilt in 1971, then renamed Cinema 101. After it closed in 1990, the property was purchased by Immaculate Conception Catholic Church. (Courtesy of Gary Voelker.)

LAKEBRINK FLOORING COMPANY. This panel truck could be seen on area streets and roads for several years when Sylvester "Syl" Lakebrink had a flooring business in Union. He later served as city collector and city clerk. He married Viola Swoboda, and the couple raised 11 children in Union. (Courtesy of Mark Lakebrink.)

ORIGINAL MAUNE STORE. The first C. Benjamin Maune store was located at the present site of the KLPW radio station north of Union. This general store carried everything early settlers needed. Customers bought or bartered for eggs, butter, and other farm products. Christian Benjamin Maune married Lilly Matilda Winters, and they had three children, Dorothy, Allen, and Bernice. (Courtesy of Dorothy Maune Sudholt Williamson collection.)

MAUNE BROTHERS STORE. This 1908 store was at the southwest corner of Main and Linden Streets. In 1912, a new store was built that later housed the Union Senior Center and is now home to El Ranchito Mexican restaurant. The store carried everything from dry goods to player pianos. Shown in the foreground are, from left to right, Ben Obermark, Jesse "Cap" Owen, and owners Henry and C. Benjamin Maune. (Courtesy of Dorothy Maune Sudholt Williamson collection.)

BLACKSMITH SHOP INTERIOR. Although this Union shop has not been positively identified, it likely belonged to Louis Danz, and provides a great view of the interior of a working blacksmith shop. (Courtesy of the author.)

DANZ FAMILY. The Danz family poses in front of the F.C. Danz General Store on North Washington Avenue. Several of F.C. Danz's sons later operated automobile dealerships in Union. (Courtesy of Franklin County Historical Society.)

LOUIS DANZ BLACKSMITH SHOP. Louis Paul Danz, an enterprising blacksmith, proudly stands in front of his new blacksmith shop on North Washington Avenue about 1888. Along with his eldest son, Herman, Danz built wagons and caskets, and even engaged in some undertaking. When the railroad was completed to Union in 1887, Danz was eager to move his business to the county seat. (Courtesy of Rose Marie Neher.)

DANZ GENERAL STORE IN NORTH UNION. Louis Danz built a general store across the street from his blacksmith shop in 1904. The store, which had a stone foundation, was located across from Hagie's Nineteen on North Washington Avenue. It was operated by Frank Danz around 1908 and by Conrad Rieger in 1914. Rieger had married Mollie Danz. (Courtesy of Rose Marie Neher.)

AHOLT'S AG MARKET. Aholt's Market on East Main Street was located in the Raymond Purschke building, which housed Angelia's restaurant until it burned down a few years ago. Shown here are, from left to right, Agnes Aholt, Marvin Means, Leo Aholt, and Karl Shanks. Aholt's Market was an Associated Grocer (AG) store. A Federated store occupied the right-hand side of the building. (Courtesy of Don Bevfoden.)

KLPW ENGINEER DON HOBELMAN. Don Hobelman was the engineer who helped Lester P. Ware get KLPW on the air. He went on to work at several radio stations, then returned to school, earning a degree in physics. Hobelman retired from McDonnell Douglas and now lives in the St. Charles area. (Courtesy of Tim Farris.)

CLAUDE VAN LEER'S TAVERN. Claude Van Leer had a tavern on what is now the south parking lot of Hagie's. The men standing in the above photograph are the owner, Claude Van Leer (center) and his brother-in-law, Frank Fink (right). The identity of the man seated at left is not known. Below, bartender Frank Fink poses for this June 1912 photograph inside the tavern on North Washington Avenue. The patriotic display would have been created for Memorial Day. (Both, courtesy of Union Historical Society.)

HOWARD FAMILY RESTAURANT. This photograph of the John Henry and Ida Mae Howard restaurant was taken in 1919. It was in Union, approximately where the new judicial building is today. Howard had earlier operated a meat market in St. Clair, but sold it in 1917 and moved to Union because his daughters were working in the Hamilton Brown Shoe Factory. (Courtesy of Tamie Brueggemann.)

HISTORIC HENRY'S TAVERN. Henry Stuckenschneider and a partner operated this tavern at the corner of Church and Main Streets in the 1930s. Today, Francis Overschmidt owns the business, known as Elmer's Tavern. It has housed a variety of occupants, including a grocery store. Stuckenschneider, who died in 1943, had an earlier tavern in the Union Hotel. The building to the right is Freddy Graham's barbershop. (Courtesy of Larry Stuckenschneider.)

OLTMANN FUNERAL HOME. In 1908, Louis Oltmann and his son, Fred, started Oltmann Hardware and Undertaking in Gerald. The photograph above shows Ella and Fred Oltmann with their horse-drawn hearse, the first in Gerald. In 1923, Louis, Fred, and Ella Oltmann moved to Union and operated the funeral business from their Park Street home. Today, the Oltmanns don't own the Gerald funeral business, but Oltmann descendants operate funeral homes in Union and Washington. Fred's son, Ralph, and wife, Lois, grandson Keith, and wife, Theresa, operate the Oltmann Funeral Home on Church Street. Their daughter, Jessica, operates a Washington branch. The early Oltmann furniture and hardware business (below) was on North Washington in Union. (Above, courtesy of Dorothy Maune Sudholt Williamson collection; below, courtesy of Helen Blesi.)

REINHARD BROTHERS, LATER JOHN MCHENRY'S STORE. The Reinhard Brothers' general store was a fixture in Union for several decades. Started by Charles Reinhard Sr., his sons, William F. and Charles P., continued the business after his death. It was located at the southwest corner of the courthouse square, facing Oak Street at Locust Street. When the Reinhards closed the business, John McHenry operated a general store there for several years (below). McHenry's store offered merchandise ranging from dry goods to groceries and hardware. By November 1913, the Reinhard heirs were offering the building for sale. The Reinhard family later owned Reinhard's drugstore on the northwest corner of the square, which has been beautifully restored and is an attorney's office. (Both, courtesy of Franklin County Historical Society.)

CHARLES REINHARD SR. Charles Reinhard emigrated from Prussia about 1829. He married Christina Dress. Their children, many of whom were influential in Union, were William Frederick, Augusta Louise, Charles P., John N., Paulina, Alfred E., Alvina Christina, Emma Caroline, John C., Olive L., Flora G., Emmert, and Viola Reinhard. Paulina married Hudson Halligan. Charles Sr. served the Union cause during the Civil War. (Courtesy of Paula Hein collection.)

WILLIAM MEYERSIECK. William Meyersieck emigrated from Germany in 1839. He married Catherine Hartmann, who was born in Prussia. After farming for several years, they moved into town in 1886. Meyersieck served as public administrator from 1878 to 1882 and owned the Union Livery Stable in 1886. Their children were Albert, Otto A., Oscar Ervin, Anna, Clara, and William M. Several became prominent in the community. (Courtesy of Paula Hein collection.)

Joseph Sager. Three men, all of whom came from Austria-Hungary, now Slovenia, started Crystal Ice and Fuel in 1921, when ice was cut from the river and packed in sawdust and straw. The owners were Louis Uhlrich, John Toroha, and John Hutter. Joseph "Joe" Sager, also from Slovenia, lent them the money for the operation and soon ended up with the ice plant. He had been living in St. Louis, but came to Union and, in partnership with George Herbst, ran Crystal Ice and Fuel until his retirement in 1961. Sager's son-in-law, Henry Schmitt, entered the business and later bought Herbst out. Joe Sager was known for his amazing ice carvings. His grandson, Bennett Schmitt, now operates the plant. (Courtesy of Schmitt family.)

CRYSTAL ICE AND FUEL. Crystal Ice and Fuel is housed in what was once the historic Vitt's Mill (above). Other businesses that have been located in the building include Stone Bridge Distillery and Union Bottling Works. David Overschmidt owned the bottling works in 1915. By 1920, George Gildehaus owned the business. He later moved the operation to Ray Purschke's old garage facing North Mulberry Avenue, behind the second Purschke garage that stood where Bugsy's restaurant is today. Shown below are the 1947 Crystal Ice and Fuel employees. They are, from left to right, John Overschmidt, George Herbst, Henry Platt, Joe Sager (owner), and Charles Skornia. (Both, courtesy of Schmitt family.)

CRYSTAL ICE AND FUEL'S MULES. These working mules pulled the ice wagon before Crystal Ice and Fuel had trucks. The team was often used to pull floats for parades. Owner Joe Sager is driving the team in this photograph. (Courtesy of Schmitt family.)

CRYSTAL ICE AND FUEL TRUCKS. Vintage Ford trucks were part of the Crystal Ice & Fuel fleet from the era when the ice plant was operated with steam engines. This year-round business found a ready market for ice in summer and coal in winter. When a customer needed ice for their icebox, they left a sign in their window indicating 25, 50, 75, or 100 pounds. (Courtesy of Schmitt family.)

CENTRAL HOTEL. Originally known as the Home House, this hotel was built about 1855 by J. Paulus and Marie K. Dress. Prior to building the hotel, Dress, who arrived in Union about 1843, was an early shoemaker. Although the hotel has had a series of owners and several names, it is probably the oldest business in Union to have continued in operation in one location. (Courtesy of the author.)

GEORGE SUDHOLT'S DAIRY FARM. The Sudholt Dairy Farm was located at 610 East State Street. The property was later owned by Jerry Borgmann. George Sudholt, a former mayor, donated land where the old high school was built. He served as mayor of Union for several terms. (Courtesy of Dorothy Maune Sudholt Williamson collection.)

EARLY LIVERY STABLE. The Vitt and Son Livery Stable was located on Block 78 in the 1898 plat of the town of Union, not far from Vitt's Mill. It is not known which Vitt family members owned it. (Courtesy of Franklin County Historical Society.)

VITT'S MILL FLOODED. Because the mill was so close to Flat Creek, which ran into the Bourbeuse River, it was subject to flooding. In this 1915 photograph, the mill is surrounded by floodwater. (Courtesy of Pautler collection.)

VITT'S MILL. About 1860, John T. Vitt built his mill, which, by 1868, was owned by his sons, Herman W. and Alfred A. Vitt. In 1880, Alfred became sole owner. Vitt's Mill was the first steam mill in the county. The oldest industrial building in Union, it is still in use as Crystal Ice and Fuel. (Courtesy of Gary Voelker.)

VITT'S MILL TORNADO DAMAGE. The historic Vitt's Mill was damaged by a storm in June 1915. At the time, it was known as the Union Milling Company and was owned by Ernst Lindemann, who also owned a bakery in town. The mill was repaired and returned to service. (Courtesy of Doris Van Leer.)

THE OLD STONE BRIDGE. Fred Vitt produced Stone Bridge whiskey in 1907 at or near Vitt's Mill. Doubtless, the whiskey was named for this picturesque double-arch stone bridge that once stood nearby. The piers for the bridge were reportedly removed when Highway 47 was built. A similar bridge with a single arch was located below Goode's Mill, east of Union. (Courtesy of Pautler collection.)

VINTAGE VITT RESIDENCE. It is possible that this Union home dates to the Civil War. Although not documented, it is rumored that an Underground Railroad operation might have been associated with the Vitt property. Glennon and Nelda Klenke lived in the house for many years. (Courtesy of the author.)

HITCHING POST RESTAURANT. Oscar and Edith Yoest owned this restaurant, which was located on Highway 50 next to present-day Purschke's. Edith ran the business for several years, but by the 1940s, the Schuberts operated it. When they moved to St. Louis, the Yoest family converted it to a home. Lakebrink Refrigeration was housed here for a number of years. The building is still in use. (Courtesy of the author.)

SCHUBERT'S HITCHING POST SERVICE STATION. This business was located on Highway 50 at Church Street, immediately left of the Hitching Post Restaurant. It was owned by the Yoest family and later leased to L.G. Schubert, who operated the station around 1940, when this photograph was taken. The man shown here is Kimball Rodgers. The building is gone now. (Courtesy of Duane Campbell.)

MICHAEL W. BAUER GENERAL STORE. It is not known where the M.W. Bauer store was located. This early store catered to locals during the horse-and-buggy days. (Courtesy of Franklin County Historical Society.)

EARLY LIVERY STABLE. Patrons and employees of this unidentified early Union livery stable show off by standing on horses. One man appears to have one foot on each of two horses! (Courtesy of Pautler collection.)

BANK OF UNION. The Bank of Union was chartered October 21, 1887. Attorney A.J. Seay, later governor of the Territory of Oklahoma, is credited with having organized the bank. On December 27, 1903, the bank was robbed by William Rudolph and George Collins. After shooting a Pinkerton detective, the men led authorities on a nationwide manhunt. Rudolph escaped and was the object of a second nationwide manhunt. Both men were hanged in Union. (Courtesy of Pautler collection.)

DR. E.A. STIERBERGER. Dr. Stierberger maintained his medical office above the Bank of Union. He was a fixture in Union for many years, sometimes calling through his open window to passersby for assistance with holding down a patient while he set a broken bone. The home behind the bank in the top photograph was that of Hattie Stierberger. (Courtesy of Sandra L. Stierberger.)

WEST END CAFÉ. Herbie Houseman bought the West End Café around 1950. His sisters, Lola and Grace Houseman and Myrtle (Houseman) Rodgers, made pies for the restaurant. It was located on the southwest corner of Main and Christina Streets. Philip Frueh Plumbing and Heating Company was housed there for many years. The West End Store was on the southeast corner of the intersection. (Courtesy of Washington Historical Museum.)

STRUBBERG HARDWARE. Prussian immigrant Anton Syzmanski settled in Union in 1855 and established a blacksmith shop. The business later evolved into the Szymanski and Max Hardware Store, owned by his son, Emil Szymanski, and son-in-law, Louis Max. It evolved into Obermark and Max Hardware, then Obermark and Dufner Hardware. In 1962, it became Strubberg Hardware. Eldo Strubberg married Janette Dufner. (Courtesy of Janette Strubberg.)

BEN OBERMARK BLACKSMITH SHOP. Ben Obermark bought the Szymanski and Max Blacksmith Shop in October 1904. Obermark lost two fingers on his right hand in a planing machine accident in 1914, requiring amputation at the first joint. (Courtesy of Janette Strubberg.)

HEIN FURNITURE STORE. John Frederick Hein learned cabinet-making before emigrating from Germany in 1853. After a stint in the Civil War, he settled in Union and married Hannah (Dress) Neimeyer. He was a brother of the tailor J.W. Hein. The exact location of this store is not known. Note that A.H. Bolte, one-time lieutenant governor of Missouri, had his office above the store. (Courtesy of Paula Hein collection.)

A&W Drive-In Restaurant. Dr. Galen H. Greenstreet and Dr. Libby O. Greenstreet built the A&W Root Beer Drive-In restaurant about 1958. Ewald and Carol Strubberg purchased the business two years later and owned it for 36 years. In the early years, customers could buy a hamburger for 25¢, French fries for 15¢, and root beer was only a nickel. A popular eatery, particularly among young people, the building was not insulated and operated as a seasonal business for several years. The building and grounds underwent a major cleaning during the offseason each year. By the 1960s, there were 26 A&Ws in Missouri. In 1968, a pagoda roof was added (below). (Both, courtesy of Carol Henderson.)

MODERNIZING THE RESTAURANT. In 1978, indoor dining was added to the A&W restaurant. Prior to that, all food was served by carhops. The same year, speakers were installed for electronic ordering. Today, the building is in use as the Nothing Fancy Café. (Courtesy of Carol Henderson.)

MCCARTHY SUMMER HOME. This was one of several homes in the Union area that became a vacation destination for people from St. Louis. In the era before air conditioning, city folks often sought a respite from the heat, coming to Union on the train and going to the Bourbeuse and Meramec Rivers to fish, swim, and picnic. (Courtesy of Don Bevfoden.)

KIEWITT FARM AND DAIRY TRUCK. The Kiewitt Dairy operated out of the historic pre–Civil War family farm (below). In the above photograph, Louis Kiewitt and his son, Lemoyne, pose with the delivery truck associated with the family dairy business. The house, which is located northeast of Union, has remained in the Kiewitt family through five generations. Built by Casper Kiewitt in 1863, this historic stone structure survived the Civil War and is now owned by his great-great-grandson Duane Kiewitt. It was built from stone quarried on the farm. (Both, courtesy of Don Bevfoden.)

WEBBER OIL COMPANY. The Webber Oil Company sold Champlin gas. Shown above is the Webber tank truck, used for delivering gasoline to area farmers. Shown below are, from left to right, employee Zeke Steelmann, owner Carl Webber, and Mobil distributor Roger Roehers. (Both, courtesy of Duane Campbell.)

WEBBER OIL SERVICE STATION. Carl Webber, who was later elected county assessor, then state representative, owned this service station at the southwest corner of Oak and Locust Streets in the 1930s. A subsequent owner used the building as a Mobil station. (Courtesy of Duane Campbell.)

TIME CAPSULE. The Oltmann Funeral Home donated a vault to be used as a time capsule that was buried east of city hall on July 4, 1976. It is to be opened on July 4, 2026. Shown here are, from left to right, Keith, Lois, Ralph, Ernst and Florence Oltmann, and Jerene and Bryan Willis. (Courtesy of Don Bevfoden.)

BUY-RITE IGA FLOODED IN 1982. In December 1982, floodwater reached the height of the raft Mike Overschmidt suspended from the ceiling in the family store. Union people turned out to help the Overschmidts clean up the mess, and the store was brought back to operation a couple of months later, when this photograph was taken. The store was owned by George and Genie Overschmidt. Their son, Mike, was working as a meat cutter at the time of the flood. (Courtesy of Mike Overschmidt.)

THE COUNTY SEAT SHOPPER. Marvin Means started the *County Seat Shopper* in the late 1970s. He is seen here at left with Jim Miller (center) and John Urhmann. The business was later sold to Urhmann. The Millers printed the publication. (Courtesy of Don Bevfoden.)

THE MARTIN HOTEL. The Martin Hotel was originally the home of attorney James Halligan. After his death, it was purchased by the Martin family and converted to a summer resort, and later to a year-round hotel. Dr. Raymond F. Lichte purchased the structure in 1935. The old hotel was razed, but numerous architectural features were used in the home Lichte built at 207 Wally Avenue. (Courtesy of Amelia Peters.)

A.B. LANG, HORSESHOER. The location of the A.B. Lang business in early Union is not known. However, Doris Van Leer believes it was in the vicinity of Vitt's Mill. (Courtesy of Doris Van Leer.)

MARTIN HOTEL AND TAXI. The Martin Hotel (below) was a popular summer resort. Above, the boy standing near the 1910-era Martin Hotel taxi is Virgil Sudholt. Before air conditioning, many people came to Union to escape the St. Louis heat. The taxi picked hotel guests up at the depot. (Both, courtesy of Dorothy Maune Sudholt Williamson collection.)

C.J. ARAND'S STORE. Christ J. Arand and a customer are shown inside the Arand store which was located on the west side of the courthouse in the 1930s. The business later moved to the south side. C. J. Arand worked in the shoe factory until 1921, when he purchased merchandise from August Diekmann and opend a store. (Courtesy of Washington Historical Museum.)

ARAND STORE SIGN. This huge sign announced to one and all that the C.J. Arand Store carried OshKosh B'Gosh overalls. The Arand family has been in business in Union since 1855, when the first Christopher Arand came to Union and began making shoes, a trade he had learned in his native Germany. (Courtesy of Washington Historical Museum.)

LINDEMANN BAKERY AND CONFECTIONERY. Ernst H. Lindemann learned the baker's trade in Germany before immigrating to the United States in the 1880s. His bakery was located on the south side of the courthouse square. It was later sold to the Schulte family and relocated. At one time, Lindemann operated Goode's Mill. He also owned the old Vitt's Mill, renamed the Lindemann Mill. (Courtesy of Doris Van Leer.)

SHERWOOD KLOPPENBERG'S BARBERSHOP. The above photograph is of Sherwood Kloppenberg's first barbershop, which was located next to Urban "Nig" Freise's Corner Bar at the southeast corner of Oak Street and Springfield Avenue. Kloppenberg was drafted into the US Army two years later and closed the shop. While he was in the service, he learned that H.B. Dickey was planning to build a commercial building on Locust Street and asked Dickey to save a space for his barbershop. In the below photograph, young Adam McGlenn, the son of Marsha McGlenn, inspects his first haircut in the mirror as Kloppenberg gives it the final touches. (Both, courtesy of Sherwood Kloppenberg.)

KRAMOLOWSKY'S SALOON AND HALL. Anton Kramolowsky operated a saloon on the first floor of the two-story brick structure at right, on the corner of Main and Church Streets. This photograph is of the last mule/horse delivery made to the store before trucks were used. Kramolowsky maintained a hall for public meetings in the white building to the north. In 1909, Lucas J. Fink started the Columbia Theatre in the Hein building. The following year, he moved it to the Kramolowsky hall in order to accommodate large crowds. Fink purchased the property with the hall in 1919. The Kramolowsky family lived above the saloon until they built a home on Church Street (below), immediately behind the Union Hotel. Anton's wife, Clara (Dietz) Kramolowsky, is shown next to their first car with grandson Anthony Pautler. (Both, courtesy of Pautler collection.)

HAMILTON BROWN SHOE COMPANY. Rev. Adolph Bisping posed in front of the Hamilton Brown Shoe Company, or Hambro Factory, for this 1917 photograph. It began operation in Union in 1914 and was responsible for a building boom, as workers moving into Union needed housing. (Courtesy of Pastor Adolph Henry Bisping collection.)

OPEN HOUSE AT BROWN SHOE. In April 1958, an open house was held at the Brown Shoe Company's Union plant. Shown here are, from left to right, Ambrose Schroeder, George Pelster, Cy Murray, Mayor Albert Schulte, and two unidentified. (Courtesy of Union City Hall.)

HAMILTON-BROWN SHOE FACTORY. In early 1914, the first shoe factory in Union began operation. The Hamilton-Brown Shoe Factory brought new residents to Union. The factory was purchased by Carmo Shoe Company in 1940. The name was later changed to Wolff Shoe Company. (Above, courtesy of the author; below, courtesy of Franklin County Historical Society.)

NATIONAL COB PIPE WORKS. The Hope Manufacturing Company built the pipe factory in 1907. It is generally considered to have been the first successful factory in Union. Owned by stockholders, Oscar Meyersieck served as president and Charles P. Reinhard was general manager. By 1915, National Cob Pipe Works was producing over five million pipes per year. In 1938, the plant was purchased by Missouri Meerschaum of Washington. (Courtesy of Ralph Gregory.)

BOURBEUSE SHOE COMPANY. In 1939, Bourbeuse Shoe Company began operation. Located at 301 South Oak Street, it burned down in March 1941. Upon re-opening three months later, this sign proclaimed that the company would make its first shipment of shoes on Friday the 13th. Brown Shoe Company purchased the building and began operation in 1952. After the company moved to South Linden Street, this building was used for wooden heel production. (Courtesy of Union Historical Society.)

Four

WHERE THEY LEARNED AND WORSHIPPED

FIRST BAPTIST CHURCH. The Baptist congregation organized on January 16, 1922, and met in homes and halls until this three-story church was built at Church and State Streets. It was dedicated on June 20, 1926. In 1957, the present church was built on Highway 50. The old church, later purchased by the Methodist congregation, has since been razed to make way for a fire station. (Courtesy of Don Bevfoden.)

ST. PAUL'S LUTHERAN CHURCH. In January 1921, a group met at the Edwin Hoemann home to organize the first Lutheran congregation in Union. A church, built on Christina Street, was dedicated on June 2, 1921. Gertrude Helling, daughter of Mr. and Mrs. Orlando Helling, was baptized before the church was completed. Rev. Walter Hofius served as the first pastor. The church, remodeled and enlarged in 1952, served the congregation until 1972, when the present church was completed. The Christina Street church was sold to the Union Masonic Lodge, AF & AM, and was dedicated for use as its hall on August 29, 1972. The building, much changed in appearance, is still in use. Below, the congregation poses in front of the church. (Both, courtesy of Rose Helling.)

PRESBYTERIAN CHURCH. The original Presbyterian church once stood in the middle of the intersection of High Street (now East State Street) and North Church Street. The building doubled as a school. It was deeded to "Trustees of the Old School Presbyterian Church" on June 26, 1843, by Judge David Sterigere. Services were held there until the Civil War ended in 1865. Later owned by Dave Breid, the historic structure also served as the first home for the Catholic church, then known as St. Mary's, from 1866 to 1902. From 1910 to 1912, it was home to the German Lutheran church, later known as Zion Evangelical and Reformed Church, now Zion United Church of Christ. (Both, courtesy of Ralph Gregory.)

PRESBYTERIAN CHURCH AT PRESENT SITE. Rev. Joseph F. and Lizzie L. Fenton donated land for a new church in 1867. Services were held in this building for at least 75 years. It was razed in 1950 to make way for the present church, which was dedicated on May 20, 1951. (Courtesy of Ralph Gregory.)

ST. JOHN'S EVANGELICAL AND REFORMED CHURCH. Commonly known today as the Mantels church, this historic structure was built in 1875 at a cost of $300. Rev. Friedrich E.C. Mantels served as the resident pastor for 30 years. The congregation officially organized in 1843, and an earlier, log structure had been built near Dubois Creek. Today, it is St. John's United Church of Christ. Prior to 1912, the Mantels church served the Union community. The Zion Evangelical and Reformed Church was built because people in Union did not want to travel to Mantels in the era before automobiles were common. (Courtesy of Washington Historical Museum.)

ST. JOHN'S MANTELS CHURCH PARSONAGE. This photograph, taken by Rev. Adolph H. Bisping, shows the parsonage where he and his wife, Elise, lived from 1915 to 1917. After that, a new parsonage was purchased by the Zion church, which he also pastored. The Franklin County Historical Society occupied the Mantels building in the 1990s. (Courtesy of Pastor Adolph Henry Bisping collection.)

EARLY WOODSHED AND OUTHOUSE. When Rev. Adolph Henry Bisping served as pastor at St. John's Mantels between 1915 and 1919, this old woodshed and outhouse served a functional purpose. The outhouse was on the left side and the woodshed on the right. (Courtesy of Pastor Adolph Henry Bisping collection.)

MANTELS CHURCH INTERIOR, 1918. Rev. Adolph Henry Bisping served as pastor of this church from 1915 to 1919. His grandson, William Gottlob Berlinger, recently visited the church and was struck by how little the interior has changed in almost 100 years. (Courtesy of Pastor Adolph Henry Bisping collection.)

FIRST CHRISTIAN CHURCH. The First Christian Church was organized in 1930. Members worshipped in private homes and in a rented store until they were able to move into a new building at Reinhard Boulevard and Main Street in 1941. In June 1970, the first services were held in the present building (shown here) at 150 Joel Avenue. (Courtesy of the author.)

FIRST UNITED METHODIST CHURCH. The First Methodist Church of Union began in 1957. In 1958, the congregation purchased a building at North Church and State Streets that had been built by the Baptist church in 1926. The Methodists built a new church at 848 West Main Street, and the building was consecrated on Easter Sunday, March 26, 1967. (Courtesy of the author.)

UNION ASSEMBLY OF GOD. The Union Assembly of God was organized in 1940. Members purchased land and built a small church at 408 West Main Street, dedicated on December 7, 1941. It was later replaced by a larger building on the same site, which is now home to the Union Church of God. In 1970, this building was dedicated at 600 South McKinley Avenue. (Courtesy of the author.)

ZION EVANGELICAL AND REFORMED CHURCH. On May 17, 1912, about 50 people met to organize a church. Early services were held in the Presbyterian church. The cornerstone for the congregation's own building was laid on November 10, 1912, and the completed church (shown here) was dedicated on May 18, 1913. It was razed in 1959 to make room for the present church. (Courtesy of Pautler collection.)

VIEWS OF ZION EVANGELICAL. In the postcard view of the original Zion Evangelical and Reformed Church (above), several buildings are seen that are no longer standing. The below photograph was described by Della Steelman, age 94. She recalls living in the home to the left of Zion church with her parents, Emil and Amelia Holtgreve. The building to the right of the church was the African Methodist Episcopal church. Steelman recalls listening to the soul-stirring songs and services of the latter congregation. (Both, courtesy of Pautler collection.)

SUNDAY SCHOOL CLASS AT ZION. Mrs. E.O. Griese's Sunday school class poses in 1918. In 1914, Judge and Mrs. Griese adopted a baby girl, about 14 months old, who had been found abandoned in a vehicle in the Gray Summit area. They named her Lucille Ford Griese. Unfortunately, she was diagnosed with Bright's Disease and lived only a few months. (Courtesy of Pastor Adolph Henry Bisping collection.)

ZION CRADLE ROLL CLASS. Shown here are, from left to right, (first row) Allen Peters, Bud Pfeiffer, Bernice ?, and unidentified; (second row) unidentified, Levine Barlage, teacher Dorothy (Maune) Sudholt Williamson, Albert Barlage, and unidentified. (Courtesy of Dorothy (Maune) Sudholt Williamson collection.)

MINISTERS AT ORDINATION SERVICE. Shown here are, from left to right, Rev. Herman Koenig, Rev. Adolph Bisping, Rev. Otto Muenstermann, Dr. Wm. Baur (Eden Seminary), and Rev. Fritz Baur. This service took place at Zion Evangelical and Reformed Church in Union. (Courtesy of Pastor Adolph Henry Bisping collection.)

ZION CHURCH PARSONAGE. Zion Evangelical and Reformed Church purchased the Lucas Fink home at 410 Springfield Place for $2,475 in 1917, making payments of $200 a year. This photograph, taken by Reverend Stadler in 1917, shows Pastor Adolph Henry Bisping and his family. Reverend Bisping pastored both Zion and Mantels churches from 1915 to 1919 and earlier lived at Mantels. No longer a parsonage, the residence is still in use at 410 Springfield. (Courtesy of Pastor Adolph Henry Bisping collection.)

WORD OF LIFE CHURCH OF THE NAZARENE. Union Church of the Nazarene was established in a tent meeting at Oak and Locust Streets on July 7, 1926, with 24 charter members. In 1933, it was decided to buy the old hall they had been worshipping in at Oak and Cherry Streets. In 1943, a new church (below) was built on that site, now home to the Hansen, Stierberger, Downard, Melenbrink, and Schroeder law firm. A 13-acre site, dubbed Nazarene Acres, was purchased in 1965. Lots were sold off, and the street was named Hoffert Street in honor of the first full-time pastor, Rev. J.W. Hoffert. The church, now known as Word of Life Church of the Nazarene (above), was dedicated on Easter Sunday 1972. (Above, courtesy of the author; below, courtesy of Word of Life Church of the Nazarene.)

BISPING FAMILY ON STEPS AT ZION. Shown here are, from left to right, (on front step) Elise Marie (Baur), Hubert Paul, Theodore F.H., and Pastor Adolph Henry Bisping; (on back step) Elizabeth Dora Maria Johanna Bisping. (Courtesy of Pastor Adolph Henry Bisping collection.)

CONFIRMATION CLASS AT ZION CHURCH. The members of the March 21, 1921, confirmation class at Zion Evangelical and Reformed Church hold their confirmation certificates. Shown are, from left to right, (first row) Dorothy Maune, Vera Fink, Edna Winkelmeyer, and Lucille Mantels; (second row) Louise Berghorn, Allen Maune, Luvina Schupp, Rev. Herman Koenig, and Alma Bauer. (Courtesy of Dorothy Maune Sudholt Williamson collection.)

LUCAS FINK. Lucas John Fink served as the pipe organist at Union's Zion Church and at St. Peter's Church in Owensville. He was a skilled musician, composer, and teacher. Fink directed and played in bands, formed a saxophone octet, and played in other musical venues. (Courtesy of the Pautler Family collection.)

THE UNION CHURCH OF GOD. First meeting in the basement of the Moose Lodge on Highway 50, the congregation purchased this building on April 29, 1976. It had earlier been home to Union Assembly of God. The church congregation officially organized on May 25, 1976. The denomination is based in Cleveland, Tennessee. (Courtesy of the author.)

ST. MARY'S CATHOLIC CHURCH. This early church was dedicated on June 1, 1902. The building was razed in 1952 or 1953 to make room for the present structure. Here, a funeral procession is forming on April 22, 1917, for the trip to the cemetery. The deceased was a popular shoe factory worker. (Courtesy of Ralph Gregory.)

REV. HYACINTH SCHROEDER, OFM. Hyacinth Schroeder, a native of the Neier community, began his tenure at Immaculate Conception on July 2, 1908. He was described by a parishioner as "a great and remarkable man and historian, indeed!" His personal spirituality, character, and zealous work for Catholicism were memorable. This photograph was taken on January 12, 1914, the day he left the parish. (Courtesy of Franklin County Historical Society.)

IMMACULATE CONCEPTION SCHOOL CONSTRUCTION. The Immaculate Conception parochial school started on October 5, 1902, in the basement of the stone church, which was then new. Emma Reymer of Hermann taught the 20 students for $25 a month. In 1904, there were 40 students, and a second teacher was hired. In August 1905, the Sisters of St. Francis came from Indiana to take charge of the school. Sisters M. Andrea, M. Maura, and M. Eutropia were the first sisters to teach at the school. The attendance had grown to 74, and there was a definite need for a new school. Construction began on March 25, 1915. (Both, courtesy of Barbara Jeffs.)

WORK PROCEEDS ON IMMACULATE CONCEPTION SCHOOL. Brother Leonard, OFM, and Brother Angelus, OFM, were the architects for the new structure, the total cost of which was less than $20,000. The first floor consisted of a kitchen, dining rooms for the sisters, priests, and children, a parlor, music room, community room, and guest rooms. In the rear were two well-lighted classrooms with cloakrooms. The second floor housed the sisters' dormitory, with a porch, separate sleeping areas for boys and girls, the sisters' chapel, a third classroom, and space for a fourth classroom. The basement, with 10-foot ceilings, included a well-lighted hall, a children's playroom, a cellar, and a boiler. The structure included a large attic. (Both, courtesy of Barbara Jeffs.)

IMMACULATE CONCEPTION CONVENTS. The earliest convent (above) was a commodious frame building. The present convent (below) was originally the Albert J. Gorg home. The Gorg property included a carriage house, which is still standing. Gorg, who was a tremendously successful businessman, married Amelia Cordelia Dunbar in 1892. In 1919, when Gorg needed to move to St. Louis to better manage his business interests, he sold the home to Joseph Mintrup. Following her husband's death, Amelia Gorg had a home built at 108 North Oak Street in Union, the only house in town with a tile roof. Joseph Mintrup sold the Gorg home to the church for $15,000 in 1946. It was remodeled, and the sisters moved in on Labor Day 1951. (Above, courtesy of Franklin County Historical Society; below, courtesy of the author.)

BETHLEHEM PRESBYTERIAN CHURCH. This charming stone church, located northeast of Union, was built in 1866 at a cost of $2,300, including the bell and steeple. The congregation eventually merged with the First Presbyterian Church in Union. Abandoned, the structure was used for hay storage. It burned down around 2001, leaving four somewhat-charred stone walls, mere remnants of the historically significant structure. In 2003, when these photographs were taken, an effort was undertaken to preserve the church, spearheaded by Roland Goessling Bauer, great-grandson of early minister Rev. William Goessling, and historian Elsie Webb. Real estate developers were planning to reconstruct it as a community center for the subdivision. However, 10 years later, nothing has been done. (Both, courtesy of the author.)

UNION HIGH SCHOOL. The Union High School, completed in 1917, is still in use. It now forms part of the Union Middle School at West End and Delmar Avenues. Albert J. Gorg was contractor for the construction. (Courtesy of Ralph Gregory.)

UNION PUBLIC SCHOOL. This photograph of the Union Public School was taken in 1908. The building was torn down when Central Elementary was built. (Courtesy of Ralph Gregory.)

UNION GRAMMAR AND HIGH SCHOOL. This is a different view of the 1908 photograph on page 92. The structure was built in 1887, but razed in 1938 to make way for the new Central Elementary School. (Courtesy of Ralph Gregory.)

L'OVERTURE SCHOOL FOR BLACK CHILDREN. Before integration, the L'Overture School provided for the educational needs of Union's black children. The African Episcopal Church, located next to Zion Evangelical and Reformed, apparently served as a school and a church. When Zion wanted to expand, the church purchased the building shown here, which then served as the L'Overture School, in exchange for the property they needed. The building still stands, but is now used for storage. (Courtesy of the author.)

CENTRAL ELEMENTARY SCHOOL. Central Elementary, designed by Washington architect Francis J. Goodrich, was built in 1938. It sported an attractive cupola that housed the school bell. Goodrich was engaged to Doris Danz, daughter of Union residents Edward and Viola Danz. When Goodrich was awarded the contract to build Central Elementary, he felt they could afford to get married. The school was razed to make way for the present building. (Courtesy of Gary Voelker.)

EARLY SCHOOL BUS. This early-model school bus is parked in front of principal Monte Murray's home. Murray lived next to the present Lutheran church. The bus driver has not been identified. (Courtesy of Pautler collection.)

1921 UNION GRAMMAR SCHOOL GRADUATES. Shown here are, from left to right, (first row) Vera (Fink) Toliver, Adele Moore, Dorothy Giebler, and Mattie Ekey; (second row) Virgil Sudholt, Bernice (Lindner) Compton, Dorothy (Maune) Sudholt Williamson, Alma (Baur) Blum, Louise Berghorn, Wilbert Klepper, and Champ Clark; (third row) Dewey Bates, John Steinbeck, Harry Niebruegge, Harold Stoner, teacher Ben Wolff, John Arenndel, and William O'Dell. (Courtesy of Dorothy (Maune) Sudholt Williamson collection.)

LOAD 'ER UP! School bus driver Clarence Triplett waits for students to board for the trip home. Note the Meramec Caverns bumper sticker. (Courtesy of Don Bevfoden.)

1915 UNION GRADUATING CLASS. Shown here are, from left to right, (seated) Mabel (Vemmer) Holman, Rosalie Szymanski, and Marie Beinke; (standing) Eliza Bell, J. Wesley Roussin, Herbert C. Funke, Glenn Renick, and Elizabeth Szymanski. Funke became an educator and an attorney, Renick became a minister, and Wes Roussin survived severe gassing during World War I. (Courtesy of Glenn Thoming.)

1930 UNION GRADUATING CLASS. Posing for a class photograph are, from left to right, (first row) Vera Kriete, Herbert Temme, Opal Farrow, Alice Bardot, Zella Cowan, Arbie Campbell, and Cora (Roussin) Thoming; (second row) Maurice Hartman, Edna Trautwein, Glenn Means, Gilbert Tappmeyer, Alice Hanneken, Arthur Moore, Edgar Mayer, Mabel Bassman, Herman Zehrt, and class sponsor Mrs. John W. Steinbeck. (Courtesy of Glenn Thoming.)

Five

DIVERSIONS IN UNION

FINK'S SAXOPHONE OCTET. Lucas John Fink was a well-known and accomplished violinist and musician. He composed music, directed bands, taught music, and, in the early 20th century, owned a music store, roller rink, and the Columbia Theatre. The band members shown here are, from left to right, (first row) Henry Vossbrink, Charlie Diekroeger, Harry Buescher, and Louis Hausman Jr.; (second row) Walter Buescher, Herbert Steinbeck, Fink, and Gordian Busch. (Courtesy of Pautler collection.)

UNION CORNET BAND. Union was the source of considerable musical talent, and bands were always on hand to enhance local celebrations. It is not known when the Union Cornet Band organized, but they often performed surprise serenades, sometime rousing people from their sleep. A.F. Mauthe was serenaded at 9:30 p.m. on his 35th birthday in 1892. He dressed quickly and the party made its way to Moutier's Hall, where the celebration continued. In January 1900, the band serenaded Professor Charles A. Cole at the home of Anna Gorg. Another cornet band was called Farmers' Cornet Band. (Both, courtesy of Washington Historical Museum.)

UNION BAND. The Union Band organized in 1895. In 1905, it bought a new band wagon that was drawn by six horses. There was also a Union Band and Orchestra, organized on June 25, 1907, with 11 members. It often played in combination with the Forest Rose Band. (Courtesy of Washington Historical Museum.)

FOREST ROSE CORNET BAND. First called the Flat Creek Band, the Forest Rose Cornet Band was organized about 1865 by William J. Lindner, who had served as a bugler during the Civil War. Band members, not necessarily shown here, included cornet players Arthur Gorg, Robert Schiller, Emil Mantels, John A. Lindner, Herman Gehlert, Charley Maune, and Albert Lindner, plus Edwin Maune (bass horn), August Lindner (baritone), and Charley Keller (bass drum). (Courtesy of Pautler collection.)

SONNY LEFHOLZ BAND. The Sonny Lefholz Band was a much-requested group for several decades. Several members of the unit were from Union. Shown here are, from left to right, (first row) unidentified, Emmet Ming, unidentified, Herbert P. "Herb" Houseman (standing with bass), and Sonny Lefholz; (second row) "Doc" Steinbeck, "Babe" Danz, two unidentified, and Charlie Kramer. The unidentified band members were likely from St. Louis. Sonny Lefholz was a chiropractor in Hermann. (Courtesy of "Pud" Ming.)

CAMPING ON THE BOURBEUSE RIVER. Fishing, swimming, and camping on the Bourbeuse River have been popular activities among Union residents over the years. Some members of this group are believed to have been from the Danz family. (Courtesy of Franklin County Historical Society.)

GOING TO THE BALLGAME. These folks are headed to the ballgame. Standing are, from left to right, Tom Patke, Mercer Hundley, and Clem Horn. Those sitting include Eldo Mantels, Troy Pfeiffer, Marsh Jones, Herb Steinbeck, and Minnow Jones. (Courtesy of Washington Historical Museum.)

LOCAL PLAYERS SUITED UP. This early 1900s photograph shows Union players Alfred "Boots" Reinhard, Tom Bruch, George Moutier, August Hoffman, Dr. Barnett Wyllie, Harry Semonsk, and four others. The coach's shirt appears to read "St. Louis C of H." The St. Louis identification is a mystery, as these are Union boys. (Courtesy of Washington Historical Museum.)

TRIBUNE BALL TEAM. The *Franklin County Tribune*, a longstanding Union newspaper, actively supported the community. Shown here are members of the 1909 "Tribunes" ball team, in uniform and ready to take on the opposition. (Courtesy of Washington Historical Museum.)

FATS AND SLIMS BALL TEAM. The Fats and Slims Ball Team, which appears to have been sponsored by Hambro, posed for this photograph in the 1920s. In the 1930s, there was a Fats and Leans team. William Lerbs, a candidate for county treasurer, died of his injuries on September 7, 1938, after falling while running to first base during a Fats and Leans game. (Courtesy of Washington Historical Museum.)

DECORATION DAY PARADE. Soldiers marched in this Decoration Day Parade around the time of World War I. This photograph provides a street view of the east side of the courthouse square. Visible are the Rexall Drugstore and Ware's Grocery store. (Courtesy of Washington Historical Museum.)

MEMORIAL DAY PARADE. The Union Band turned out for this Memorial Day Parade. The Union Hotel, which had many owners and went by several names over the years, was owned by Michael Moutier at the time of this parade. (Courtesy of Union Historical Society.)

FRISCO TRAVELERS. The Frisco Travelers held their ninth annual convention in Union in June 1920. The event included three days of fun and entertainment, including a band concert, minstrel show, dance, "Mardi Gras" parade, field day, banquets, and a drawing for a new Ford. (Courtesy of Franklin County Historical Society.)

EARLIEST PARADE PHOTOGRAPH. This photograph depicts a Memorial Day Parade. Participants are crossing the railroad tracks and heading north on Washington Avenue. Early parades ended at the cemetery north of town. (Courtesy of Union Historical Society.)

PARADE, 1930s. The location of this parade scene from the 1930s has not been determined, but the sign on the building at upper right indicates it is a bus station. Note the early police cars. (Courtesy of Union Historical Society.)

ST. LOUIS PARTICIPATION IN UNION PARADE. In 1964, the magnificent Anheuser-Busch Clydesdales (above) were brought to Union to be part of the Memorial Day parade. The St. Louis Drum and Bugle Corps (below) also came out to participate in the festivities. (Courtesy of Mark Lakebrink.)

Six

ROADS THEY TRAVELED

FORDING THE RIVER, 1923. During the early years of the automobile, Franklin County roads were inadequate, and bridges were few and far apart. Fording streams was common, but horses and wagons were better suited to this practice than automobiles. Building roads and bridges became an important focus of local and state government for several decades. (Courtesy of Pautler collection.)

UNION ROCK ISLAND DEPOT. After decades of negotiations and finagling, the St. Louis, Kansas City & Colorado Railroad was finally built to Union, years after rail service had reached the neighboring towns of Washington and St. Clair. The final stretch of track was laid on June 4, 1887. The line was later known as the Rock Island Railroad. Passenger service was discontinued in 1950. (Courtesy of Union Historical Society.)

LONG-TERM RAILROAD AGENT. Railroad agent John Gunn is shown seated at his desk in the Union depot in the 1920s. The railroad telegraph is behind him. The depot clock, at left, was set daily by wire from Washington, DC, and served as the official time for Union residents. Elmo Witcher served as station agent for 13 years, retiring in 1964. (Courtesy of Union Historical Society.)

EARLY RAILROAD ACCIDENT. This train wreck took place on the Rock Island Railroad one mile east of Union on February 9, 1910. Passenger train No. 28, also known as the St. Louis Express, was running 35 minutes late and apparently encountered spreading rails, causing it to leave the track as it rounded the sharp curve at the bridge. One passenger coach and two baggage cars were thrown down a 30-foot embankment and demolished. Conductor John D. Reach, who was in the baggage car, was instantly killed. Numerous injured passengers were treated by Dr. Stierberger, who was the official Rock Island physician in Union. In that era, rail traffic was heavy, and accidents were common. (Both, courtesy of the author.)

BUILT FOR HORSE-AND-BUGGY TRAFFIC. The covered wooden bridge over the Bourbeuse River was built in 1867 of Howe Truss construction, enclosed with a shingle roof. The bridge was 200 feet long and 22 feet high, and the roadway was 16 feet wide. Its predecessor had been destroyed during Price's Raid, when thousands of men crossed it with horses, wagons, artillery, and other equipment. Although picturesque, crossing the Red Bridge at night was a spooky experience. The bridge was long and dark. Lanterns used by drivers of buggies and wagons produced little light. Occasionally, a robbery would occur on the bridge, adding to the uneasiness of those who found it necessary to cross the bridge at night. (Above, courtesy of Gary Voelker; below, courtesy of Dorothy Maune Sudolt Willamson collection.)

TORNADO DESTRUCTION. The Red Bridge was destroyed by a tornado on April 20, 1920. It was lifted and flipped roof-first into the water. The following morning, pedestrians and camera buffs converged on the scene. Many walked on the upturned bridge, seemingly unaware that the damaged bridge might not be stable footing. Robert Mueller was the only eyewitness to the destruction. He had been fishing in a boat when he saw the funnel-shaped cloud. He tied his boat to a sapling under the bridge. Mueller saw all of the water being sucked up out of the river and dropped flat on the ground. Despite the storm wreaking so much havoc above him, he survived. He was the father of Lorraine (Mueller) Jenny and Maj. Gen. Paul Mueller. (Both, courtesy of Glenn Thoming.)

STEEL BRIDGE OVER BOURBEUSE RIVER. When Highway 50 was built, it was determined that the iron and steel bridge that had been built after the 1920 tornado was not wide enough to handle highway traffic. Although it was only about 15 years old, it was scrapped. This replacement bridge, built to the new specifications, was the last bridge at that site to sport a superstructure. (Courtesy of the author.)

GOODE'S MILL BRIDGE. This single-arch stone bridge was once located a little downstream from Goode's Mill, adding to the picturesque setting at the popular mill. Locals flocked to the cool stream to fish and swim on hot summer days, often passing the time while waiting for their grain to be milled. (Courtesy of Ralph Gregory.)

HARTMANN BRIDGE. The picturesque Hartmann Bridge provided a challenge to drivers, who had to be prepared to make a sharp turn after crossing the bridge to avoid running into the cliff! The bridge, located on North Bend Road south of Union, was a popular place for fishing, swimming, and picnicking. It was named for John and Regina Hartmann, who emigrated from Erfurt, Germany, in 1847, and settled in the area. Below, Rev. Bisping stands beside his automobile on the bridge. (Above, courtesy of Washington Historical Museum; below, courtesy of Pastor Adolph H. Bisping collection.)

FIRST AUTOMOBILE IN UNION. Louis Danz owned the first automobile in Union, a 1909 Jackson. Mollie Danz is at the wheel (on the right-hand side of the vehicle). Her brother, Edward Danz, is the front-seat passenger. Thomas Danz and their mother, Amelia "Mollie" Danz, are in the back. Thomas, Edward, and another brother, Albert, later owned automobile dealerships in Union. (Courtesy of Rose Marie Neher.)

BISPING FAREWELL. A crowd gathered at the Union depot on April 28, 1919, to bid farewell to Rev. Bisping and his family. Bisping had served the Evangelical and Reformed congregations in Union and nearby St. John's "Mantels" church for several years. (Courtesy of Pastor Adolph H. Bisping collection.)

Seven

WHO THEY WERE

WORLD WAR I CASUALTY. Henry John Berner (left) and William Fredrich Koenig were friends, and both served in World War I. Berner died of pneumonia and measles in France on October 27, 1918. His family received word of his death the following November. Funeral services were held for 23-year-old Berner at St. John's Mantels on December 1, 1918. Koenig, born on January 13, 1895, in the Krakow area, was the son of Edward and Anna (Dewert) Koenig. He married Alwina Altholz, and they had one daughter, Anita (Koenig) Jaeger. William Koenig lived to be 85 years old. Berner and Koenig were members of St. John's Evangelical and Reformed (Mantels) Church. (Courtesy of Pastor Adolph H. Bisping collection.)

Shoemaker Paulus Dress. Johann Paulus "Paul" Dress was born in Prussia in 1803. He immigrated to the United States in 1842 and established himself as a shoemaker, a trade he had learned in the old country. He was known to have walked to St. Louis and back, carrying a supply of leather on his back on the return trip. His wife helped by taking in boarders. About 1855, they built the Home House Hotel and managed it full time. The hotel, now known as Central Hotel, is still in operation as a boardinghouse. (Courtesy of Paula Hein collection.)

LOG CABIN DISCOVERED IN 2012. When a demolition crew began tearing down an old house on South Oak Street, they found an intact log cabin under the clapboard siding. Running the deed has produced a long list of property owners, but the builder of the cabin has not been determined. The logs were saved by a private individual who plans to reconstruct the cabin on his Bourbeuse River property. (Courtesy of Gail Claggett.)

POLLY GRINNUP HOME. This stone house located at 601 East State Street once belonged to Sidney Alonzo and Pauline "Polly" Jane (Matney) Grinnip/Grinnup. Later, it was the Creamery Hill Antique Shop. Reportedly built in 1842, it is sometimes referred to as a slave house, but the early history of the structure is not known. Long vacant, it appears to have restoration potential. (Courtesy of the author.)

Businessman John George Moutier. J.G. Moutier (pronounced "Moo-Shee" by locals), had a wagon-making shop in 1886, a bakery in 1891, owned the Union Hotel in 1894, and was in the general mercantile business in 1898. He also owned a brickyard in 1914, the year he was appointed postmaster of Union. (Courtesy of Ralph Gregory.)

Paula Hein. Paula Hein was the daughter of Jacob and Emma Marie Kathrine (Neimaier) Hein. She had the foresight to capture images of her family and friends. A 1904 Union High School graduate, Hein taught in the rural schools for five years. She then taught the primary grades at Union for seven years. Hein also worked for the Hansen Title Company before relocating to St. Louis. (Courtesy of Paula Hein collection.)

FRIENDS FROM CHILDHOOD. Shown here are, from left to right, Paula Hein, Paul Mueller, and Lorraine Jenny. Hein was a shutterbug who enjoyed photographing Union people and scenes. She taught school in Franklin County, worked at Hansen Title Company, then moved to St. Louis, but often returned to Union to visit friends and family. Mueller, the son of Robert Mueller of Union, graduated from West Point in 1915 in the class with Dwight D. Eisenhower. Mueller served as chief of staff for Douglas MacArthur and rose to the rank of major general. He served in World War I, World War II, and the Korean War. His sister, Lorraine, married Frank Jenny, a well-known prosecuting attorney in Union, and was involved in getting the library started. (Courtesy of Paula Hein collection.)

WELL-KNOWN UNION MEN. Shown here from left to right are Newton Corkins, Clark Brown, and Homer Calkins. Corkins and Calkins were variations of the same name. Brown was the popular editor of the *Franklin County Tribune* for many years and worked on a history of the area, which he did not complete. (Courtesy of Ralph Gregory.)

THE BRUCH BUNCH. Thomas Bruch was serving as Franklin County sheriff when Rudolph and Collins robbed the Bank of Union and shot a Pinkerton detective in 1903. Bruch married Anna Meyersieck, the daughter of William and Catherine (Hartmann) Meyersieck. The Bruch clan posed for this family photograph in 1891. The man holding the rifle is Sheriff Bruch. (Courtesy of Franklin County Historical Society.)

AUGUST AND LILY FINK. August and Lily (Detschel) Fink lived in a home on South Oak Street (below) near August's brother, John, who had married Lily's sister, Katie. They were sons of George and Catherine (Schreiber) Fink. Other siblings were George and Lucas Fink and Lena Pfeiffer. August managed and later purchased the Gorg Elevator, which he sold to Farmers' Warehouse Association. Although family members dispute this, his obituary states that he was president of the Bank of Union. His brother, John, served on the board of another local bank. August and Elizabeth "Lily" raised a foster daughter. The locket that Lily is wearing at right contains a picture of August, dressed exactly as he is in the photograph! (Both, courtesy of Pautler collection.)

THE WINTERS FAMILY. The Winters family has many descendants in the Union area. They lived in the Bethlehem Presbyterian Church community northeast of Union. Elsie (Winters) Webb and Lois Oltmann were Winters descendants. (Courtesy of Dorothy Maune Sudolt Williamson collection.)

PIANO RECITAL, APRIL 1967. Pictured are Debbie Schmucke, Jill Campbell, Belinda Brown, Peggy and Janette Henderson, Vickie and Dickie Krenning, Amy and Cindy Hagedorn, Cindy and Sidney Fees, Vickie Copeland, Mary and Becky Hall, Debbie Billings, Jeff Grob, Pamela and Rickie Hartzke, Joanne Pisane, and teacher Dorothy Williamson, along with Elaine, Cheryl, and Suzanne Lamke and Lynn, Tammy, Sherry, and Denise Hoelscher. (Courtesy of Dorothy Maune Sudolt Williamson collection.)

DOROTHY WILLIAMSON CELEBRATES 82ND BIRTHDAY. Dorothy "Dollie" Williamson sits by her piano, which symbolizes the 40 years she spent giving piano lessons to Union children. Williamson had an avid interest in local history. She collected photographs and recorded some of her recollections about life in Union. (Courtesy of Dorothy (Maune) Sudholt Williamson collection.)

SYLVESTER AND VIOLA LAKEBRINK. Sylvester "Syl" Lakebrink was a well-known Union city official. He served as city collector from 1960 until his 1967 appointment to the office of city clerk. He filled that position until his death on April 17, 1983. Lakebrink was a great resource, a walking encyclopedia of Union history. Born in Union on July 9, 1918, he was the son of William H. and Josephine (Lamprecht) Lakebrink. He married Viola Swoboda, and the couple had 11 children. Lakebrink served in the US Navy during World War II. He operated a flooring business in Union for several years. (Courtesy of Mark Lakebrink.)

THE STRUBBERG FAMILY. The Strubbergs have been and continue to be a pillar of the Union business community. Shown here are, from left to right, (seated) Leroy Strubberg, CPA, and Rose and Eldo Strubberg; (standing) Ewald Strubberg. Ewald owned the Union A&W for 38 years. Eldo Strubberg started working for the Obermark-Dufner store when he was in the seventh grade. He married Janette Dufner and, in 1962, the store became Strubberg Hardware. (Courtesy of Janette Strubberg.)

THE BEN MAUNE FAMILY. Shown here are, from left to right, (seated) Ben Maune Sr.; his granddaughter, Lois Sudholt, now Lois Oltmann; and his daughter, Dorothy (Maune) Sudholt; (standing) Ben Maune Jr. When Ben Sr. married in 1933, he issued his own marriage license because he was the recorder of deeds. (Courtesy of Dorothy (Maune) Sudholt Williamson collection.)

DISPLAYING HIS PATRIOTIC SPIRIT. Anton Kramolowsky often displayed his patriotic spirit in the form of this huge flag. Here, he stands next to the flag in front of his home, located behind the old Union Hotel. Kramolowsky, who was born in Austria in 1860, was a prominent Union businessman who operated a tavern on the northwest corner of the square for many years. He married Clara Dietz of Washington and they raised four children, Elsie Pautler, Dr. Helmuth Kramolowsky, Mrs. Lee P. Rapp, and Verna (Sister Mary Clare). Anton Kramolowsky died on April 1, 1932. The flag was made in 1878, first used in 1880, and obtained by Kramolowsky in 1895. On June 30, 1953, the enormous flag was donated to Arbie Campbell, who was commander of American Legion Post No. 297. (Courtesy of the Paulter collection.)

BIBLIOGRAPHY

Atlas Map of Franklin County, Missouri. St. Louis: Atlas Publishing Company, 1878.

Gregory, Ralph. "Sesquicentennial Contributions: The New County Seat." *Washington Missourian*, January 23, 1969, 10D.

———. "Villa Ridge Resident Tells of Confederate Raid on Union." *Washington Citizen*, October 11, 1964, 7B.

———. "Sesquicentennial Contributions: The County Seat in 1847–1849." *Washington Missourian*, January 30, 1969, 12B.

History of Missouri, Franklin, Jefferson, Washington, Crawford & Gasconade Counties. Greenville, SC: Southern Historical Press Inc., 2001.

Kiel, Herman Gottlieb. *The Centennial Biographical Directory of Franklin County, Missouri.* Washington, MO: Washington Historical Museum, 1986.

Lomax, Lucy. *History of Union, 1827–1976.* Union, MO: *Franklin County Tribune*, June 1976.

Mahon, Linda E. *Waiting for the Road: Union, Missouri to 1901.* Master's thesis, Edwardsville, IL: Southern Illinois University, 2000.

WILDSIDE PRESS NOVELS BY NICK POLLOTTA

Judgment Night

FORTHCOMING

Bureau 13: Doomsday Exam
Bureau 13: Full Moonster
Bureau 13: Damned Nation

OTHER NOVELS BY NICK POLLOTTA

Satellite Night News (as Jack Hopkins)
Satellite Night Special (as Jack Hopkins)
Satellite Night Fever (as Jack Hopkins)
Illegal Aliens (with Phil Foglio)
American Knights
Shadowboxer
The 24 Hour War
Free-for-All *
The Guardians of Cascade *

Forthcoming:

The Bureau 13 Omnibus, Drofa Press, Moskow
Hunter/Killer
Red Dagger